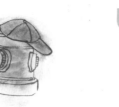

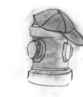

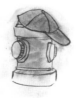

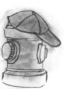

smallfellow press

Los Angeles

Forever Friends

Written by Barbara S. Cohen

Illustrated by Dorothy Louise Hall

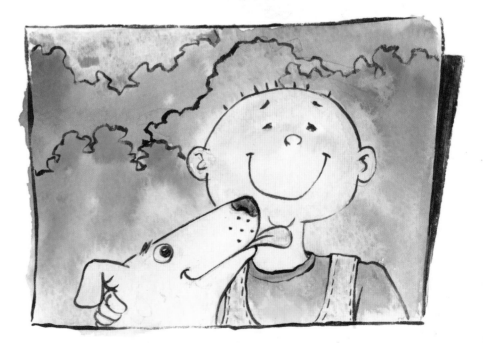

Published by smallfellow press
a division of Tallfellow Press, Inc.
1180 S. Beverly Drive
Los Angeles, CA 90035

ISBN 1-931290-12-1

Printed in China

10 9 8 7 6 5 4 3 2 1

To Skipper and Judith, my Petey and Skip, and with thanks to Peggy Anne Murphy, who got me started.
　　　　　　　　　　　　　　　　—Barbara S. Cohen

For my granddaughter, Gracie, and my grandmother, Hattie.
　　　　　　　　　　　　　　　　—Dorothy Louise Hall

My name is Petey.

This is Skip.

We're best friends.

I take good care of Skip.

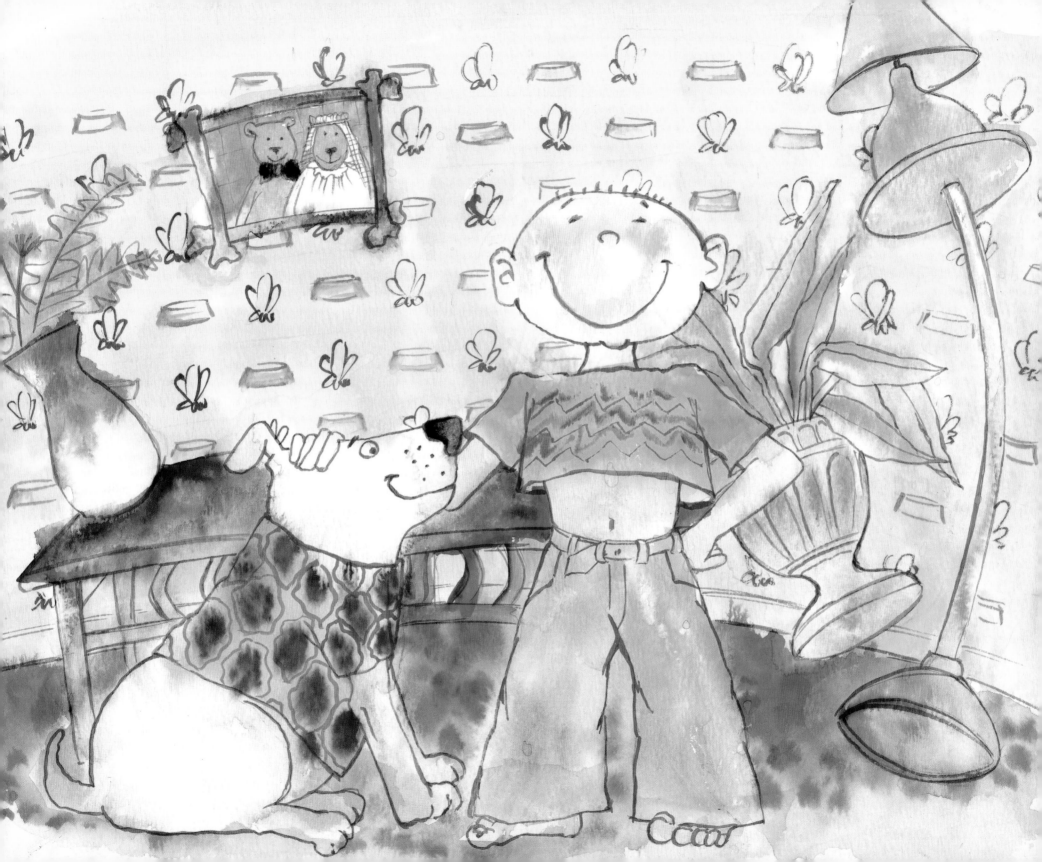

He has a hard time waking up for school,

so I help him out a little.

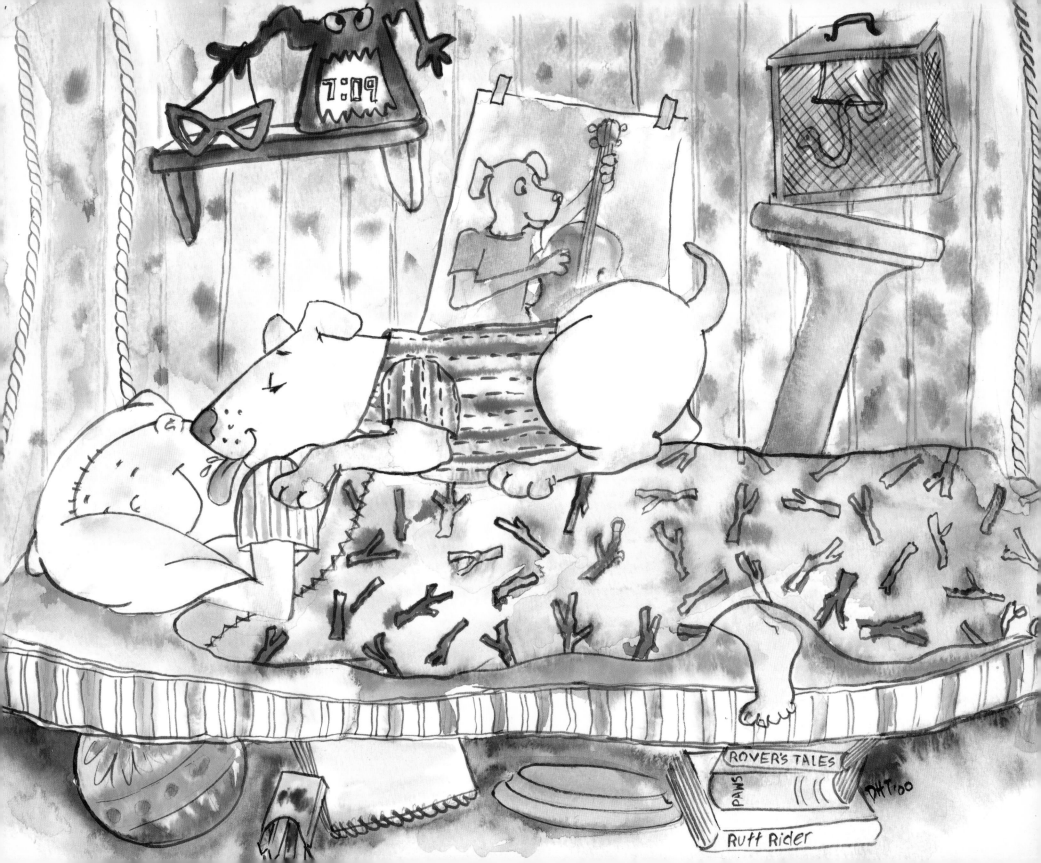

After breakfast, he is still very sleepy,
so I walk him to keep him awake.
I make sure he gets to the bus on time.

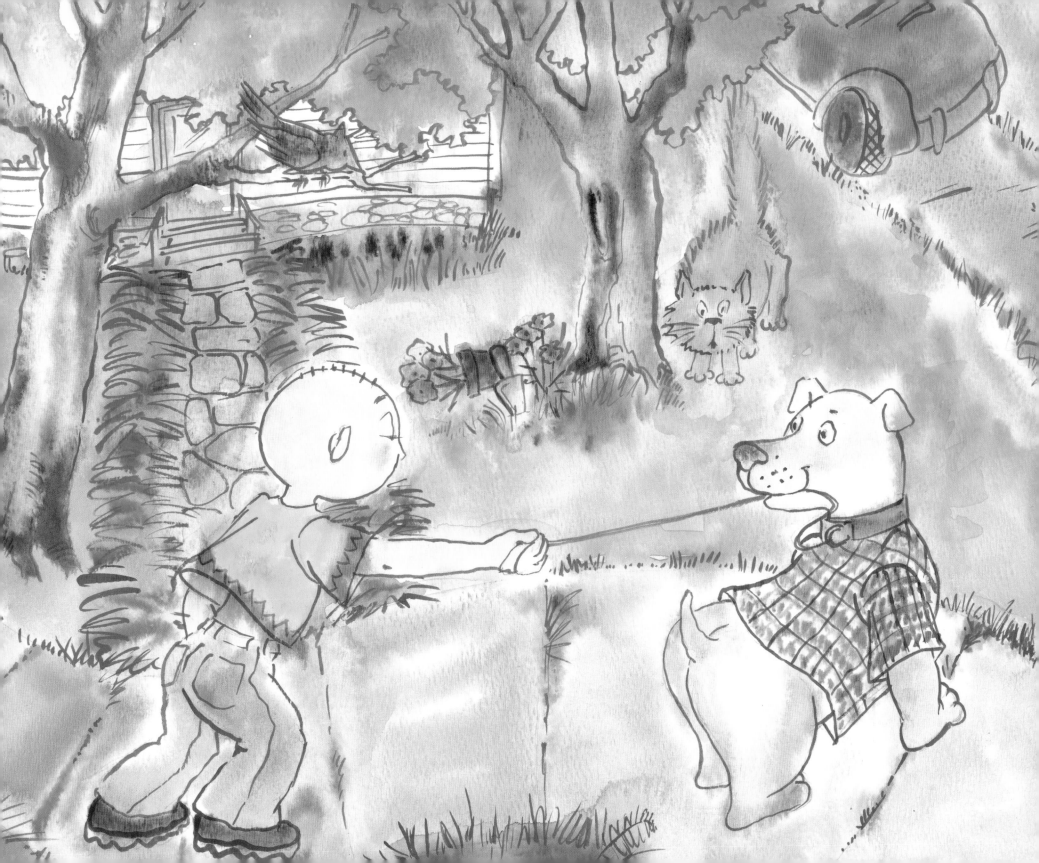

After school,

I pick him up at the bus stop.

He needs exercise,

so I play catch with him.

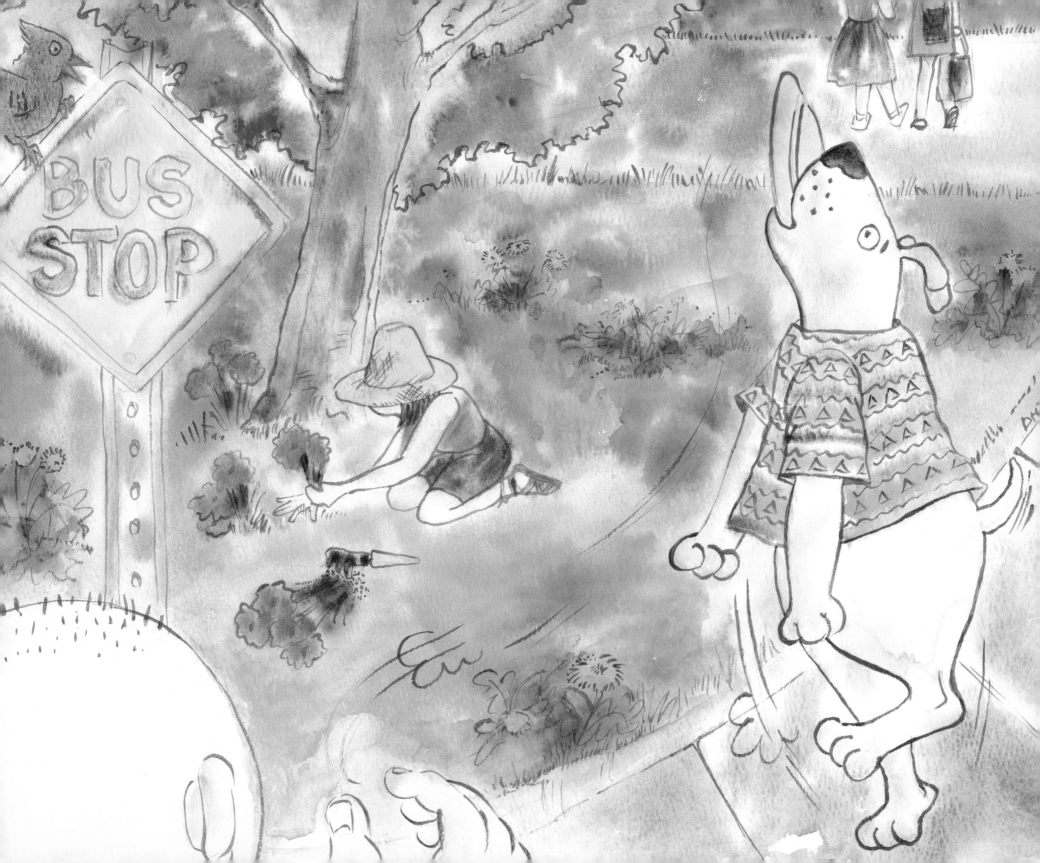

I teach him to love nature.

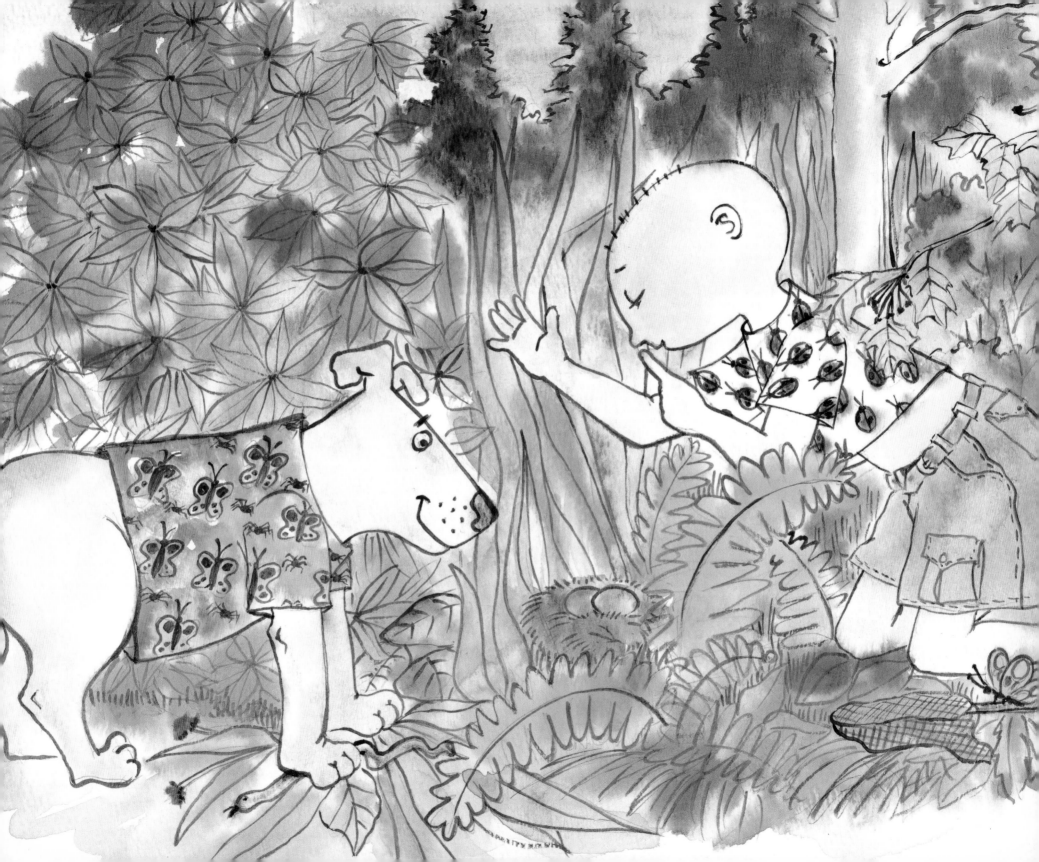

It's important for him to make friends,
so I greet the neighbors.

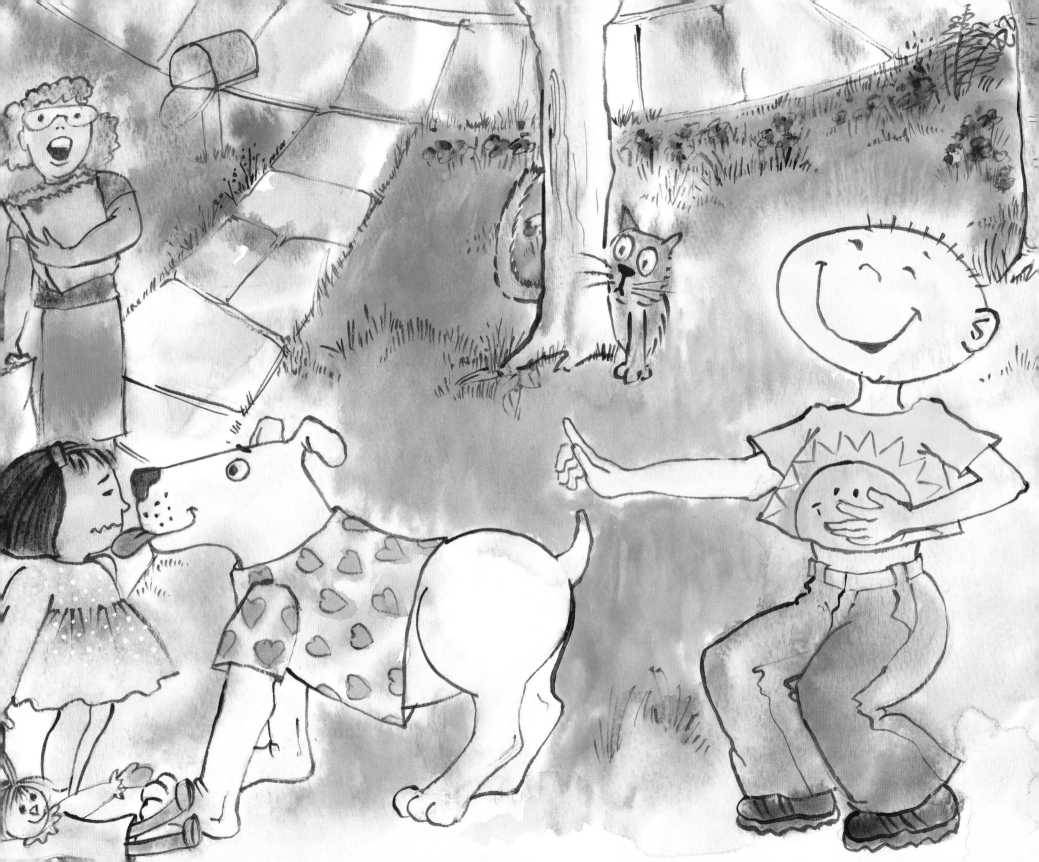

When he eats too much,
he doesn't feel well,
so I help him finish his food.
(It's a tough job!)

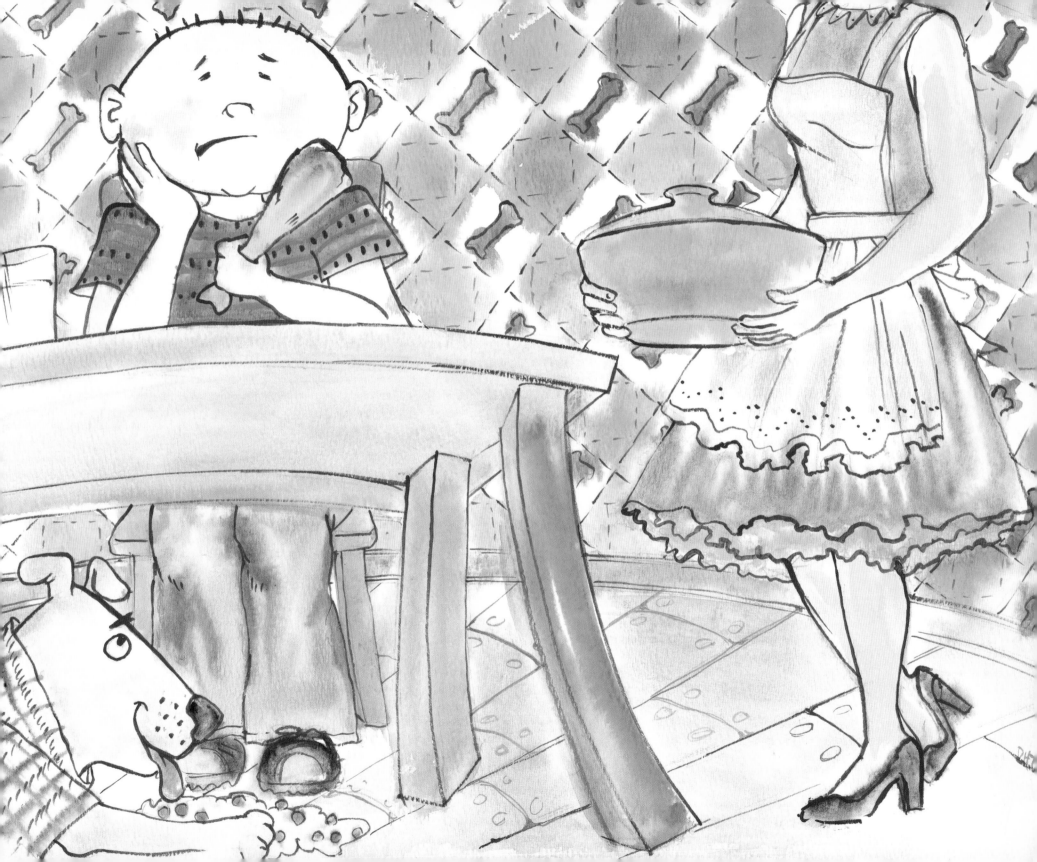

When he's sick, I take care of him.
I do tricks to cheer him up.

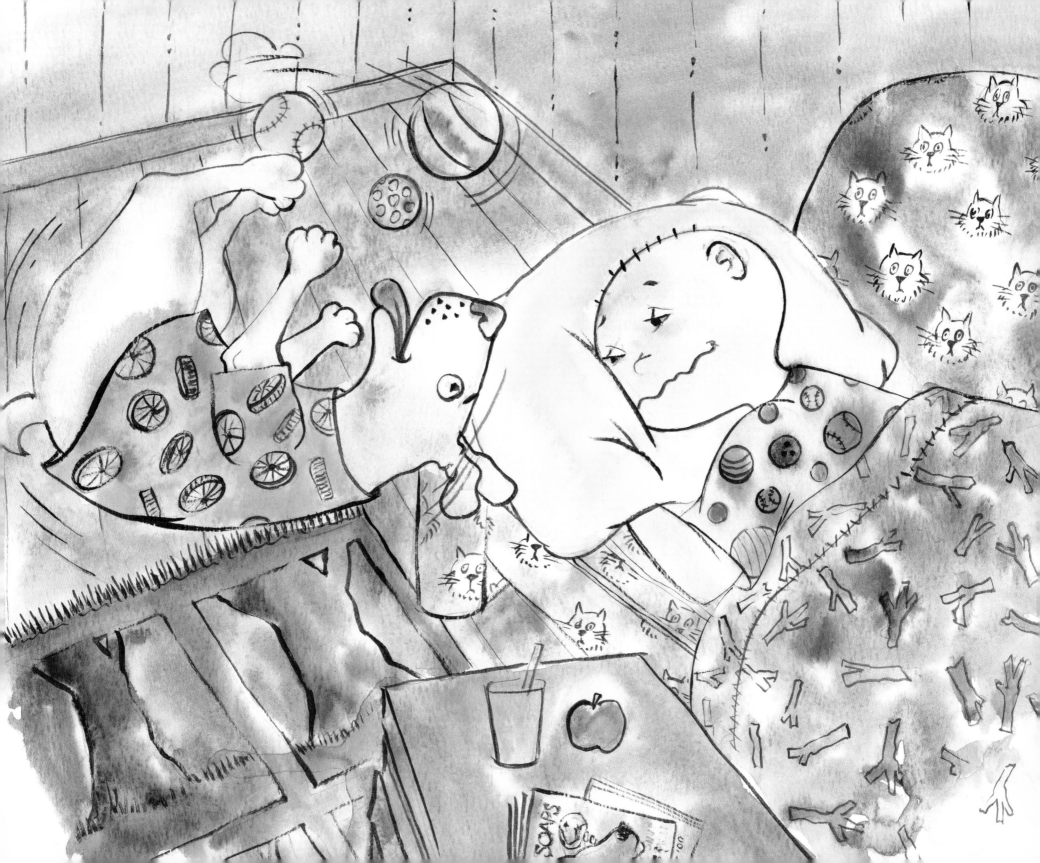

I teach him good manners.

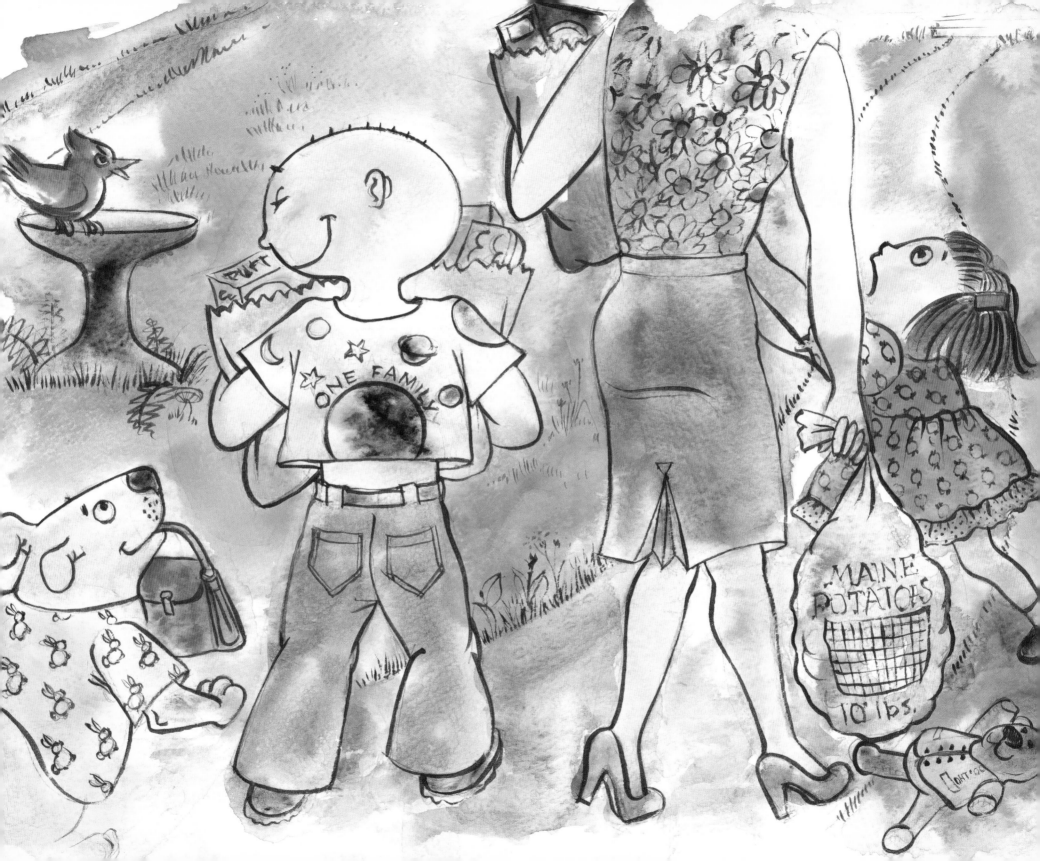

I tuck him into bed at night and comfort him if he has bad dreams.

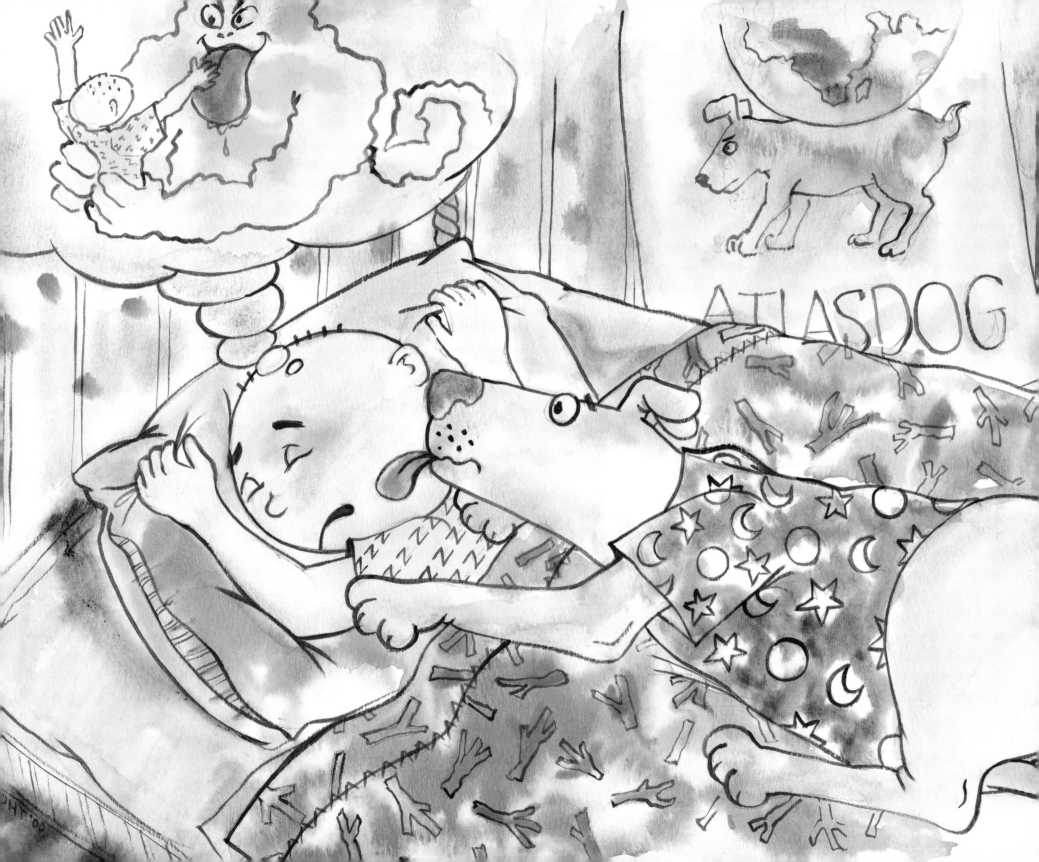

Skip does nice things for me, too.

He scratches me behind the ears.

He fills my water dish.

He gives me a bath.

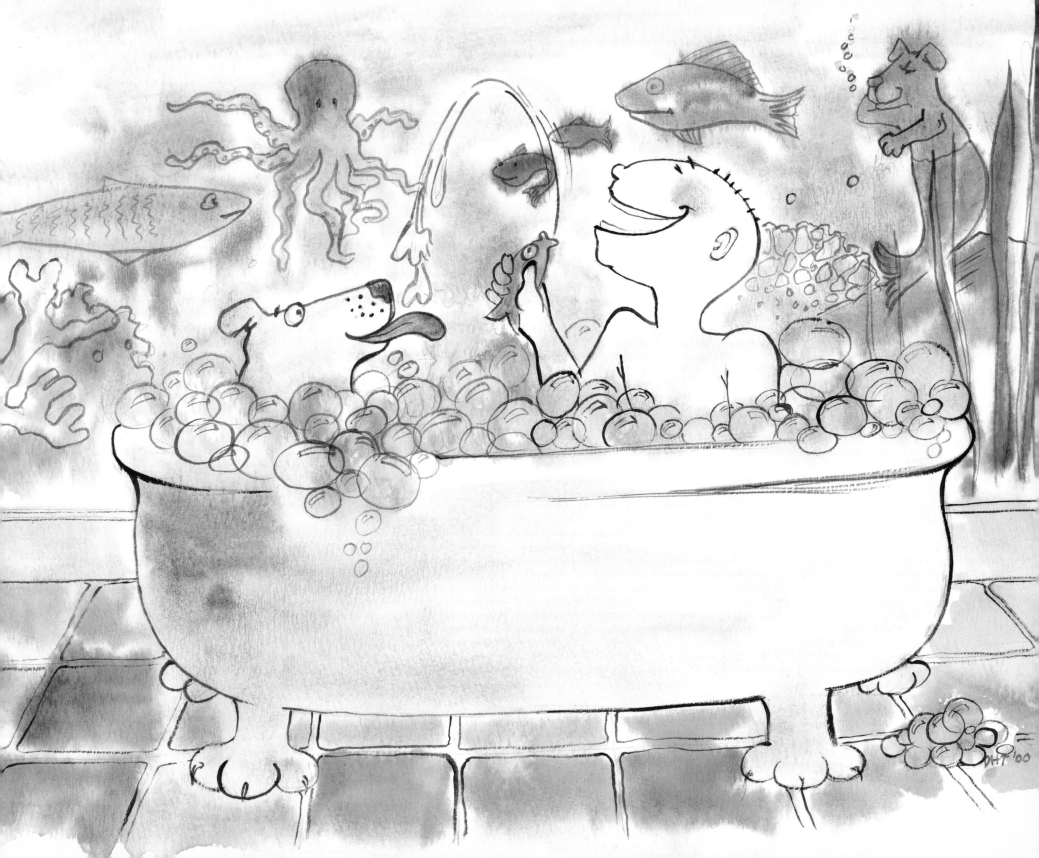

And most of all, he loves me because we're...

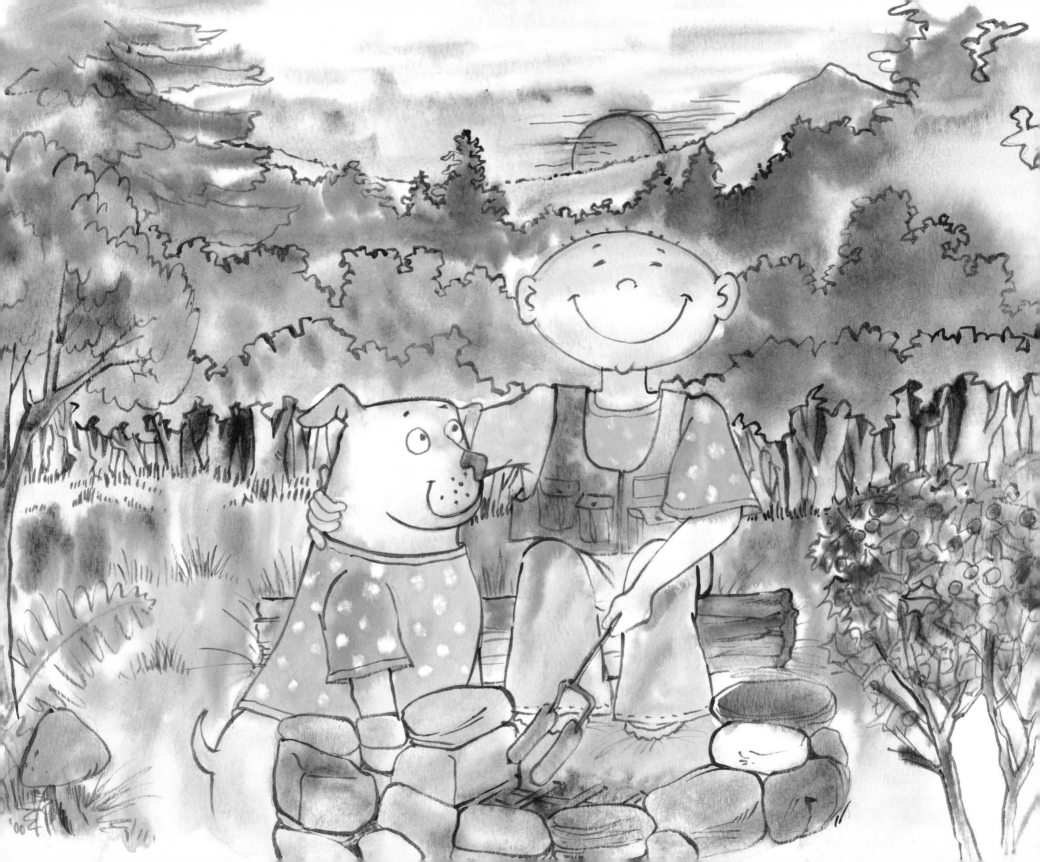

Forever Friends!

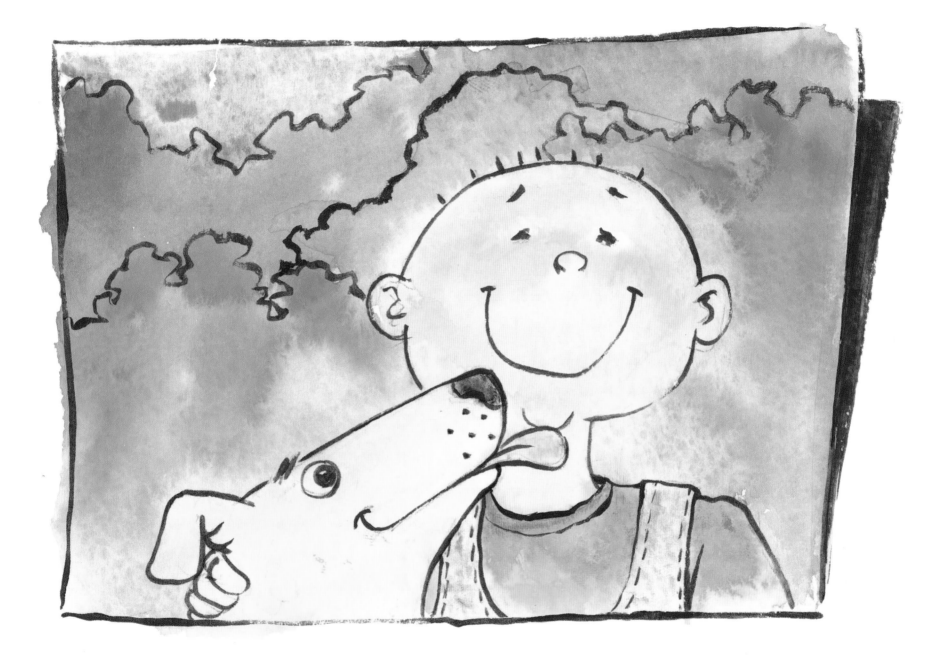